ABSTRACT PATTERNS N' STUFF

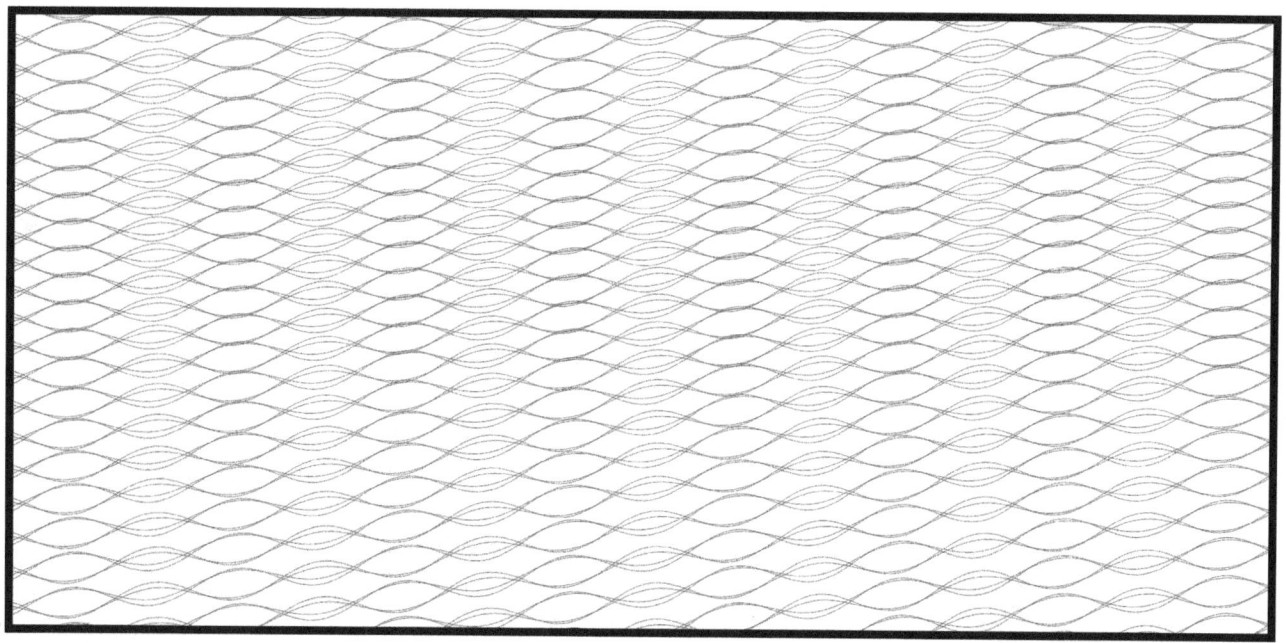

color and compose

art & direction by
Tony Kola

©2016 Tony Kola

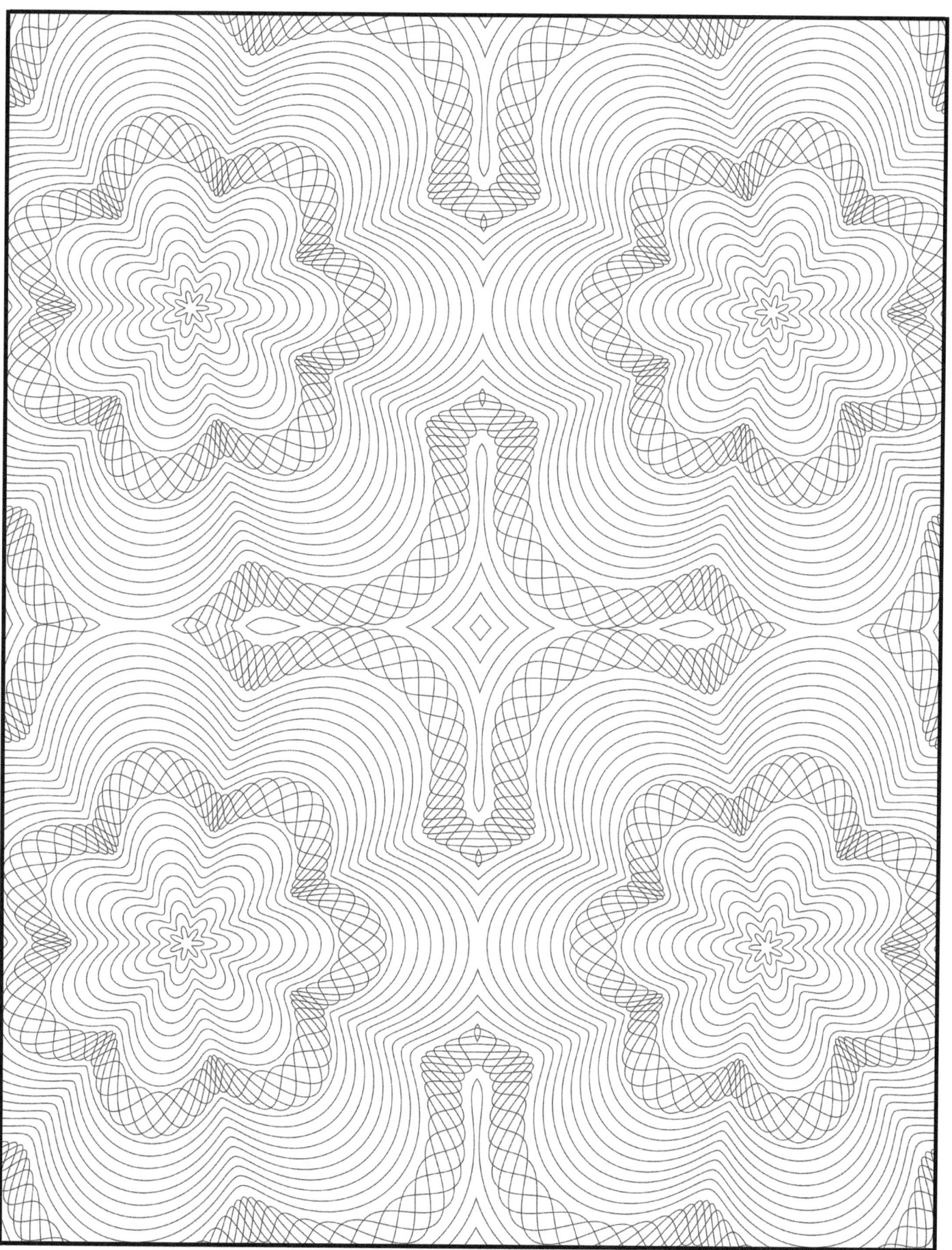

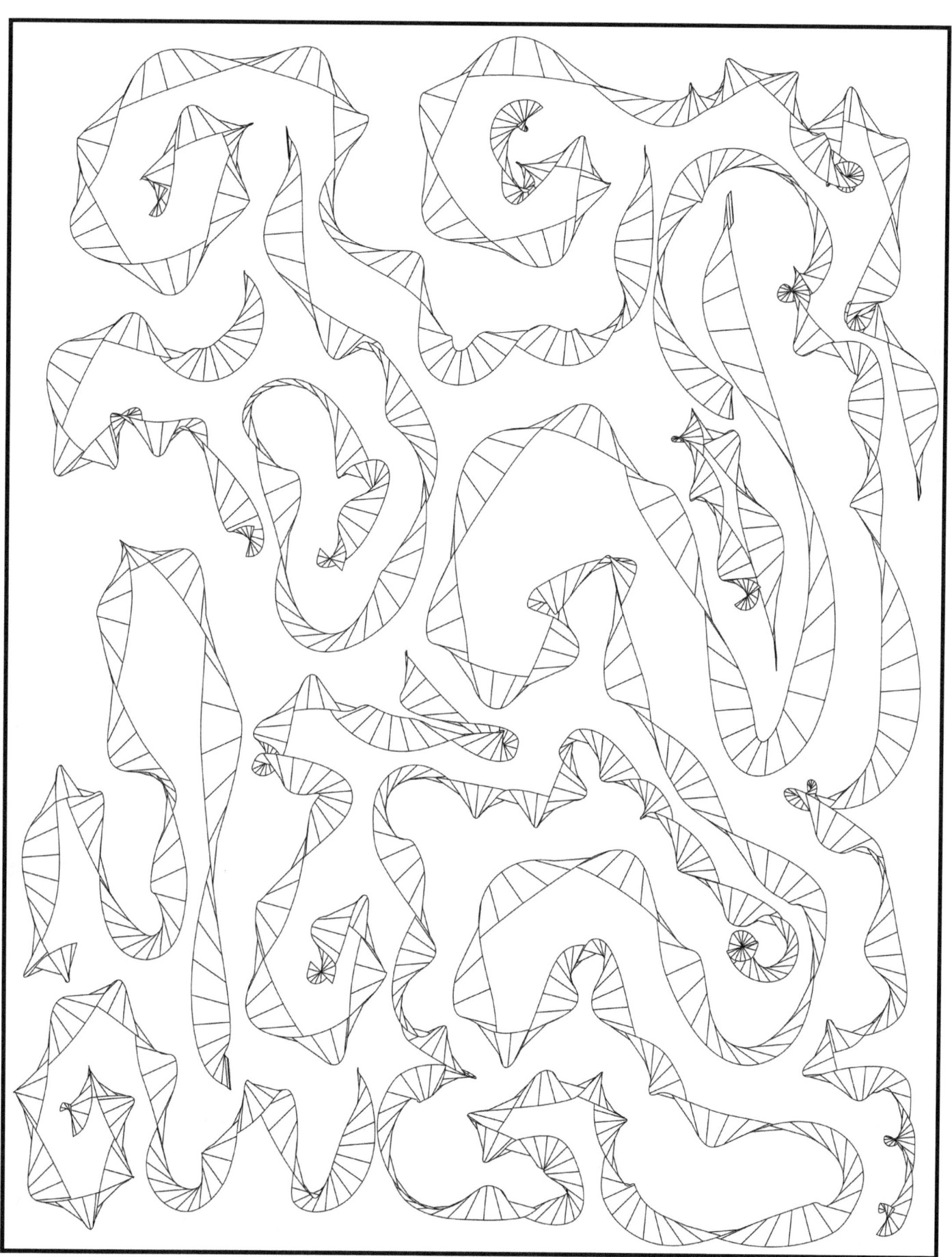

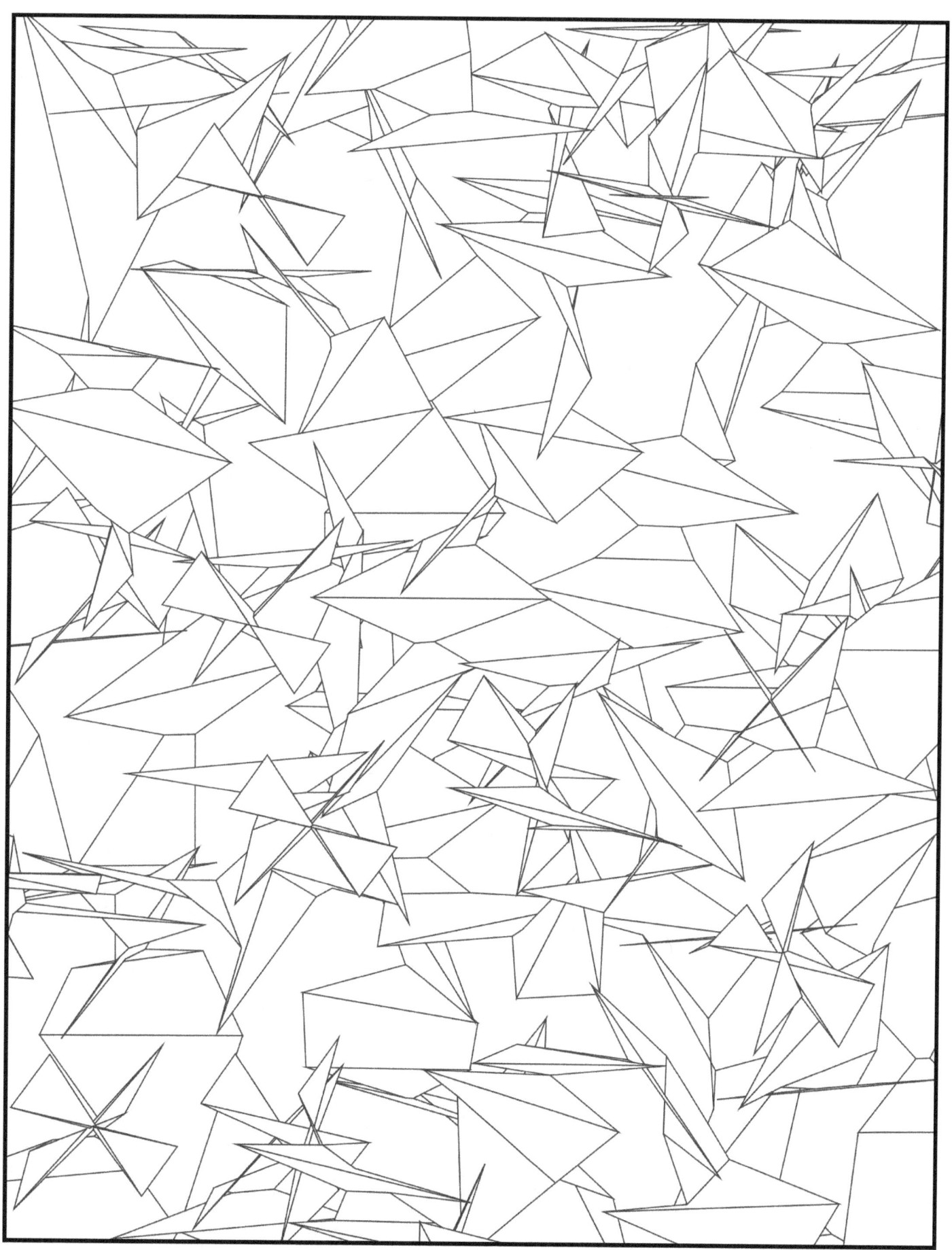

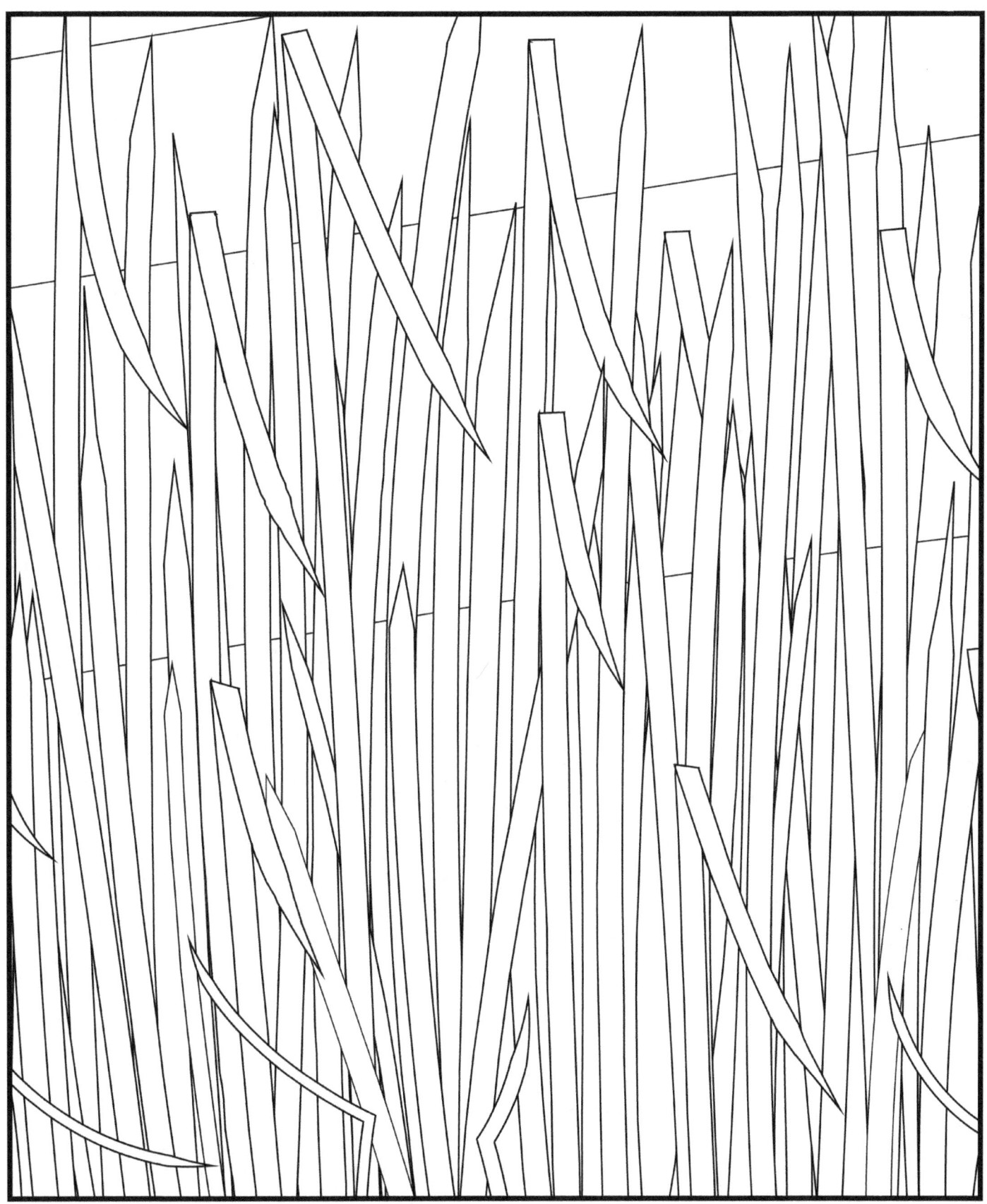

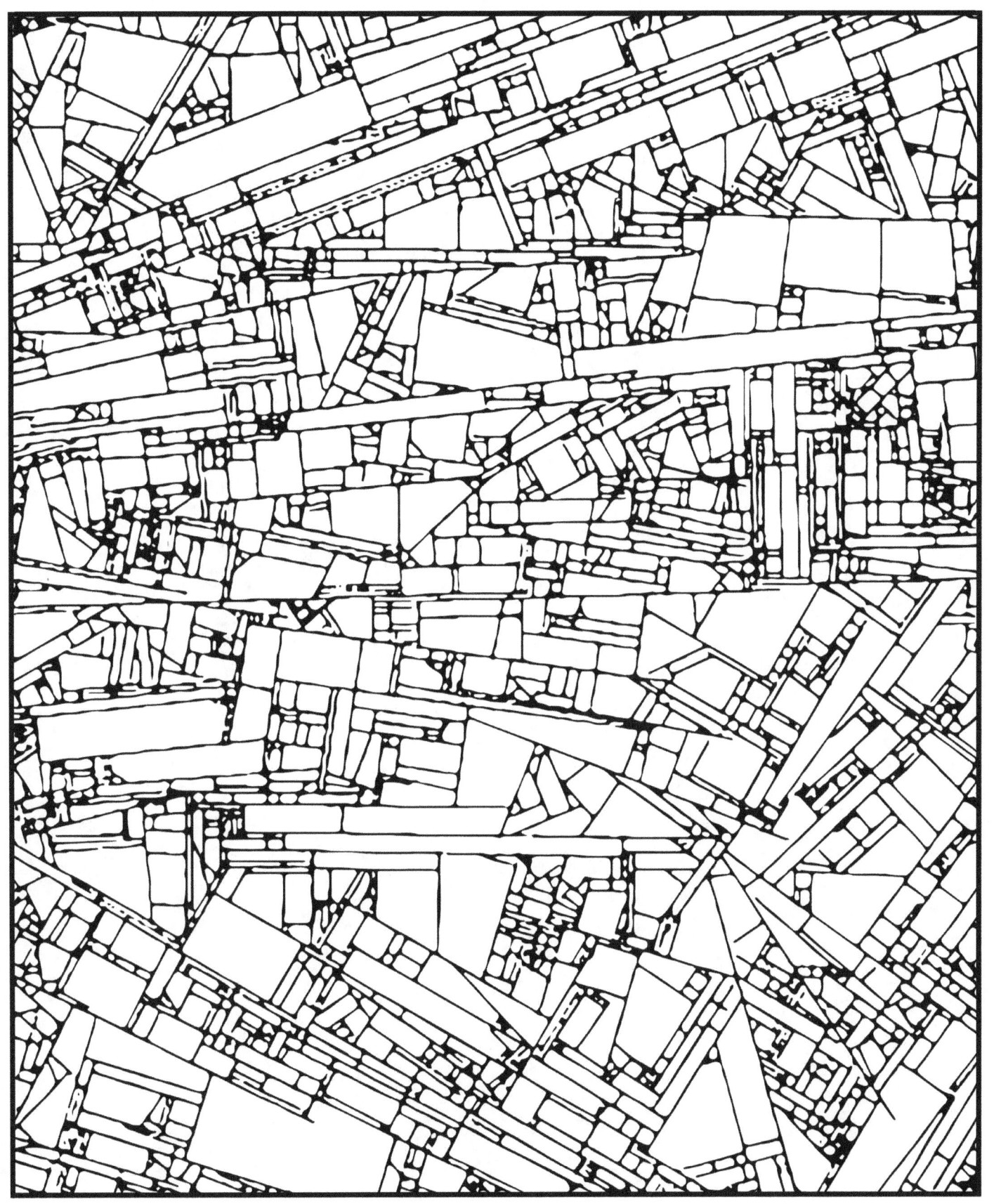

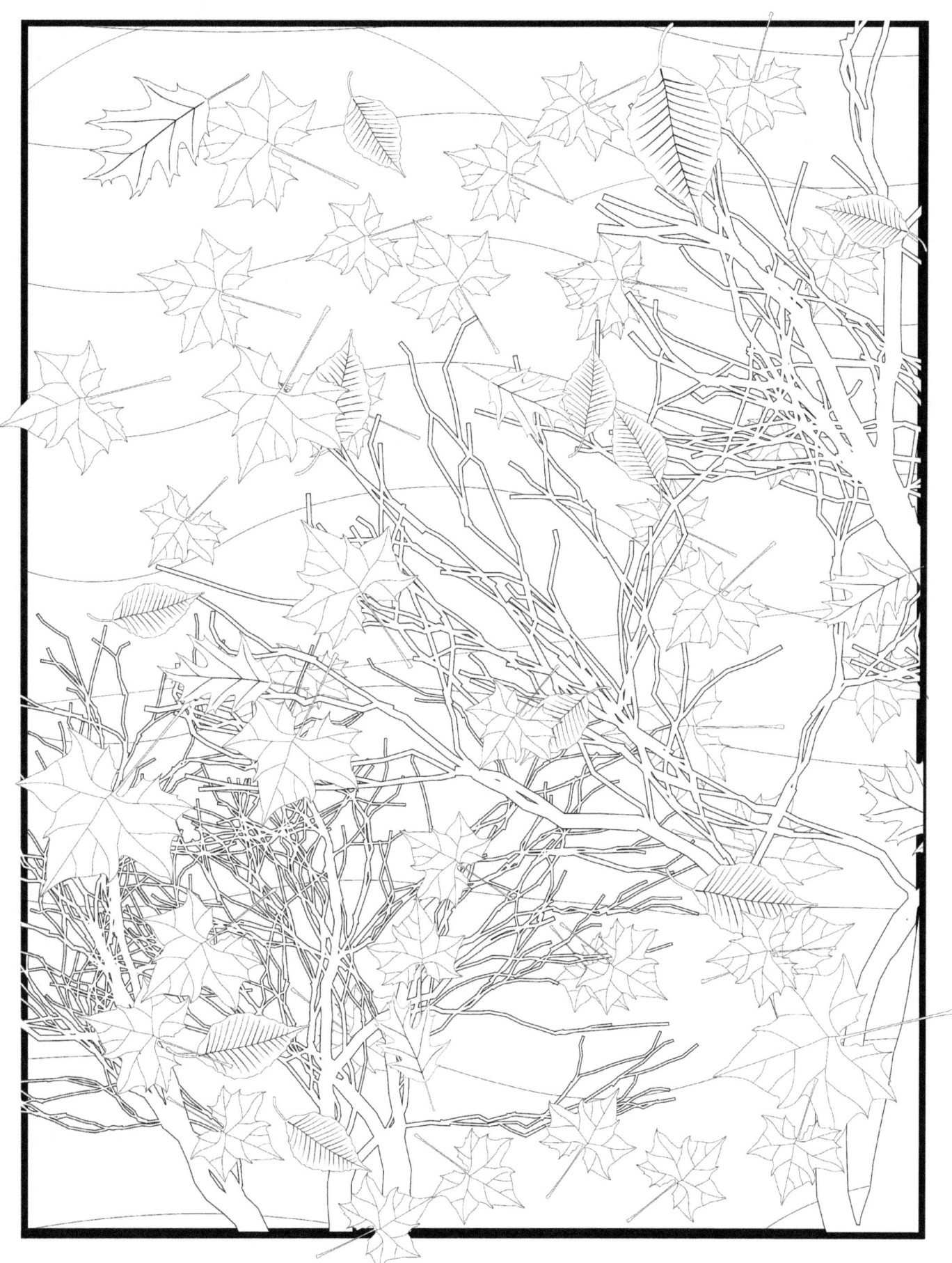

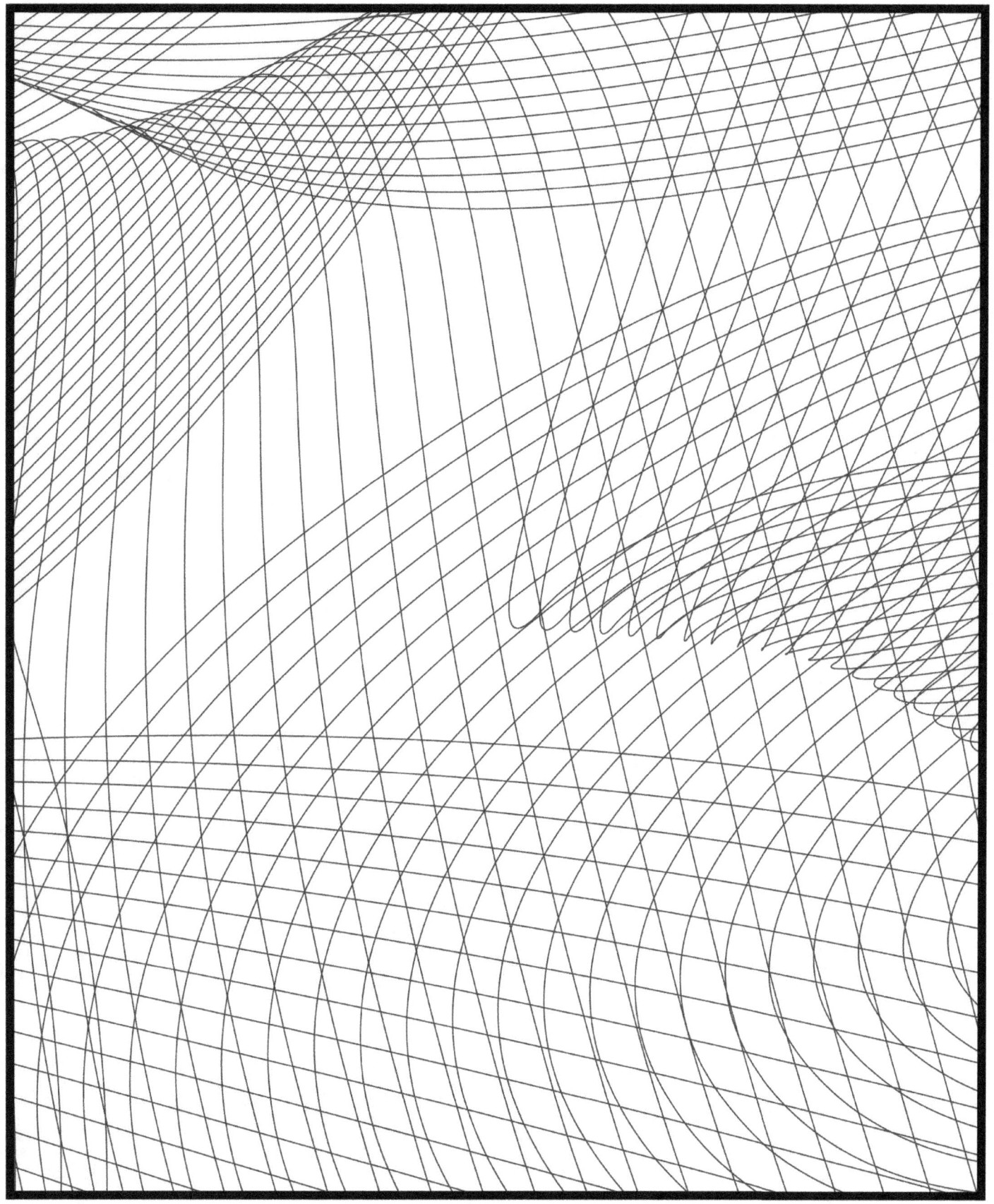

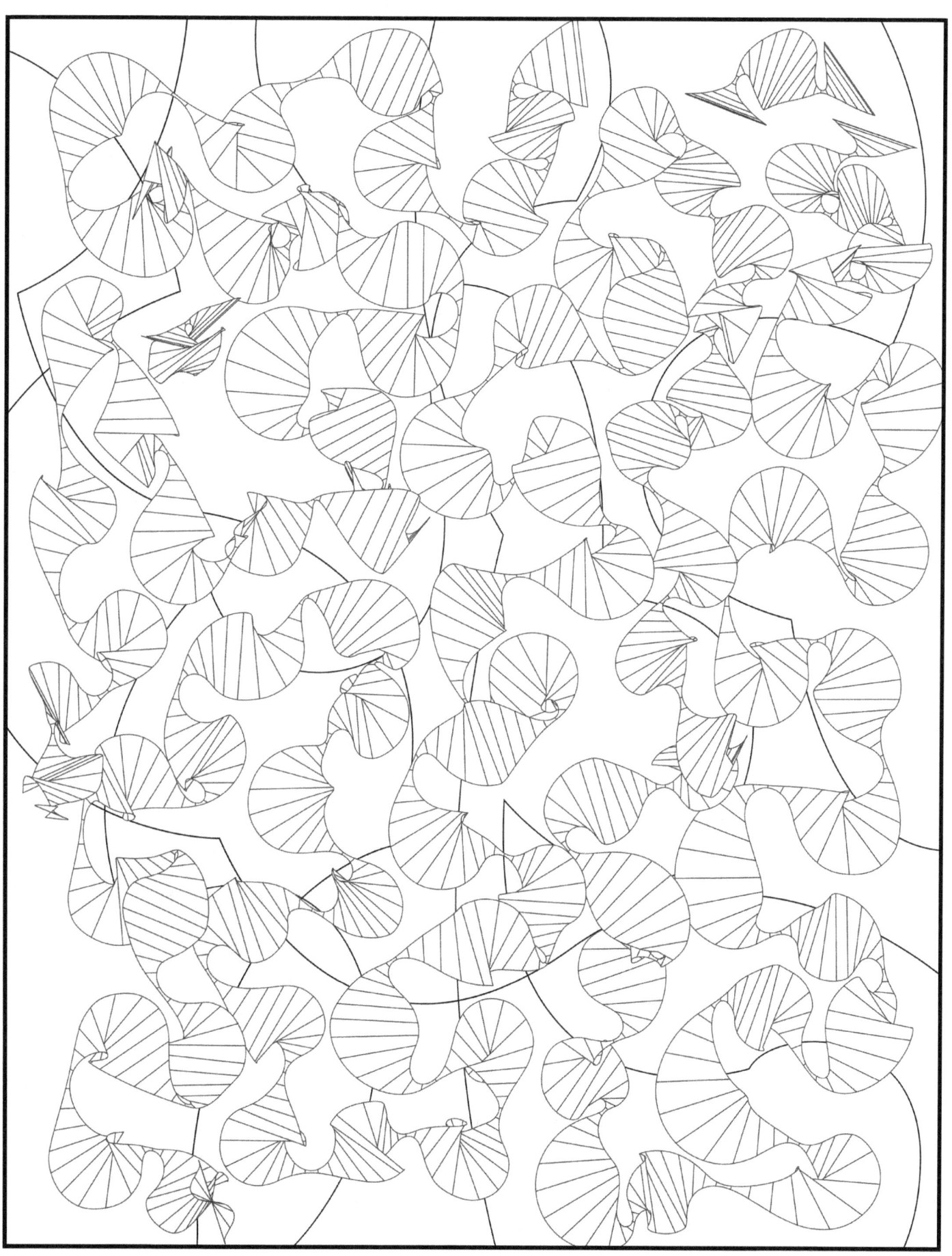

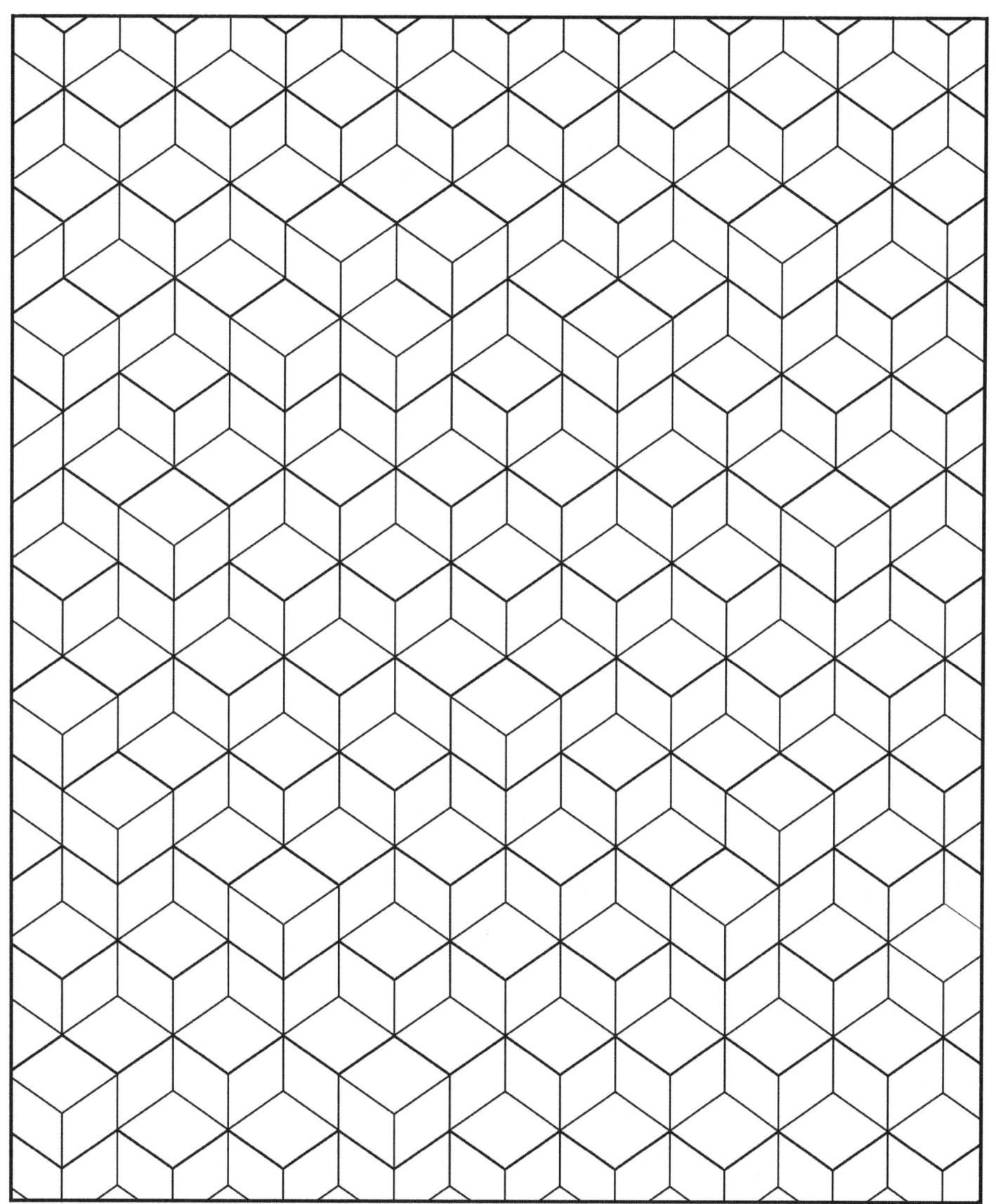

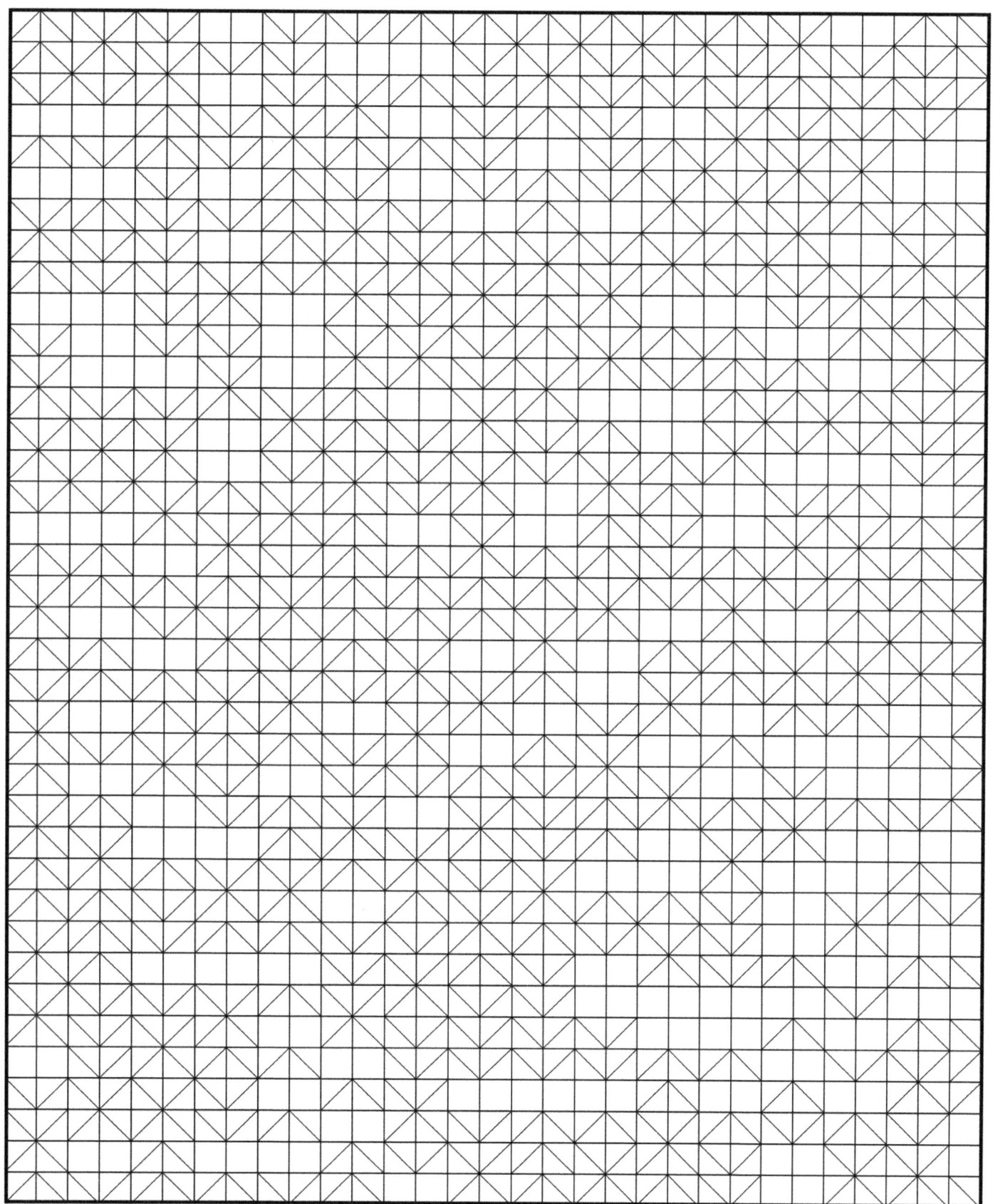

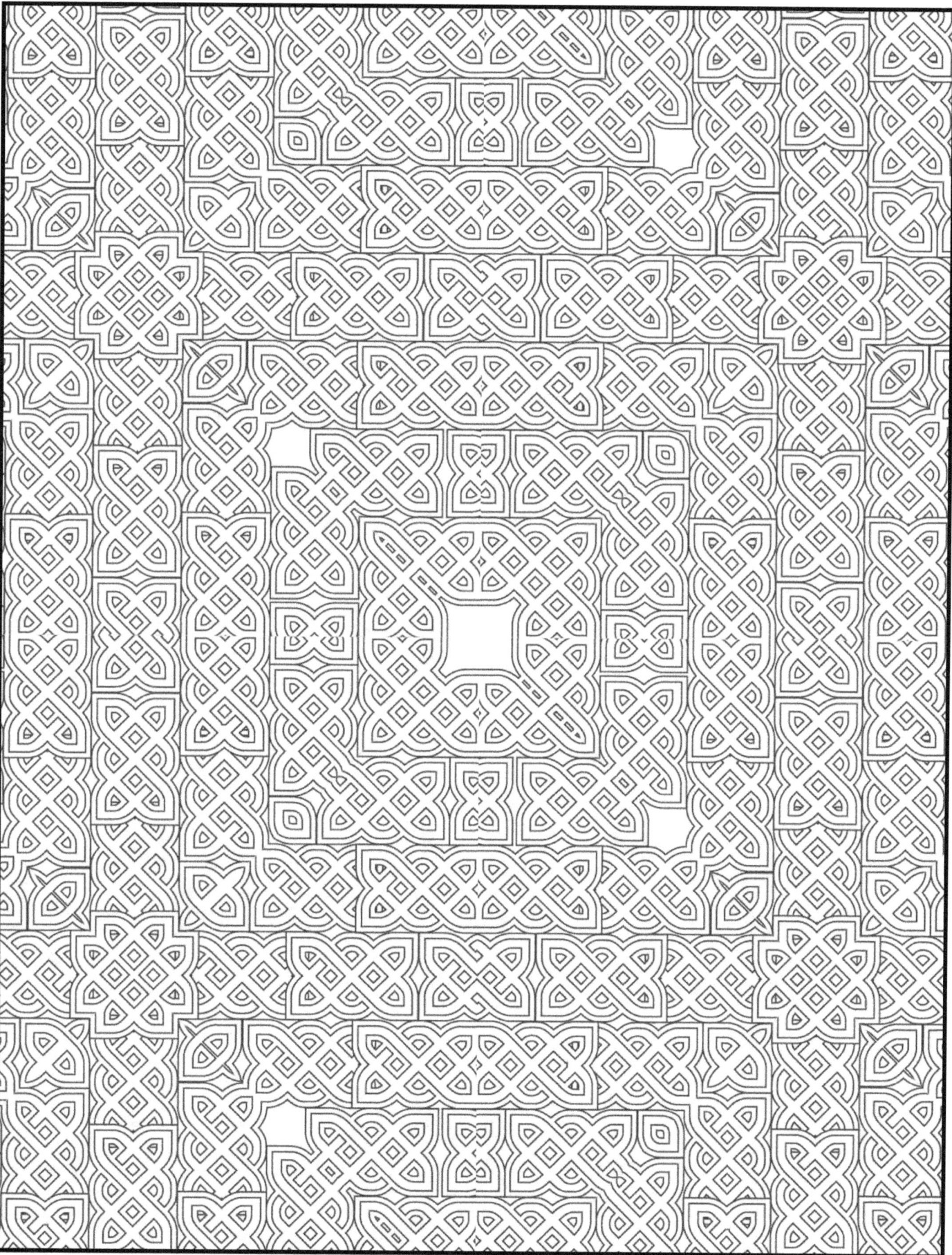

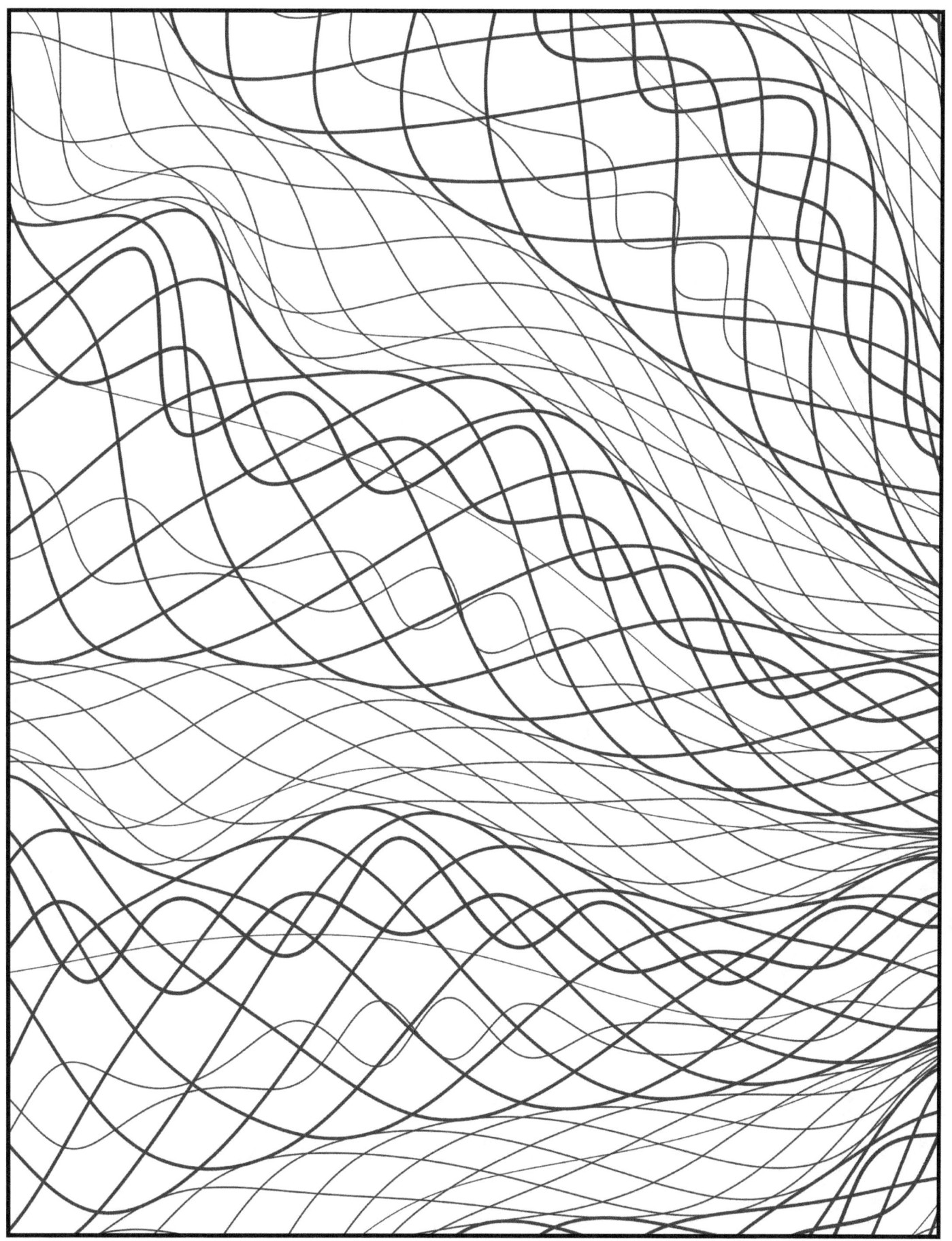

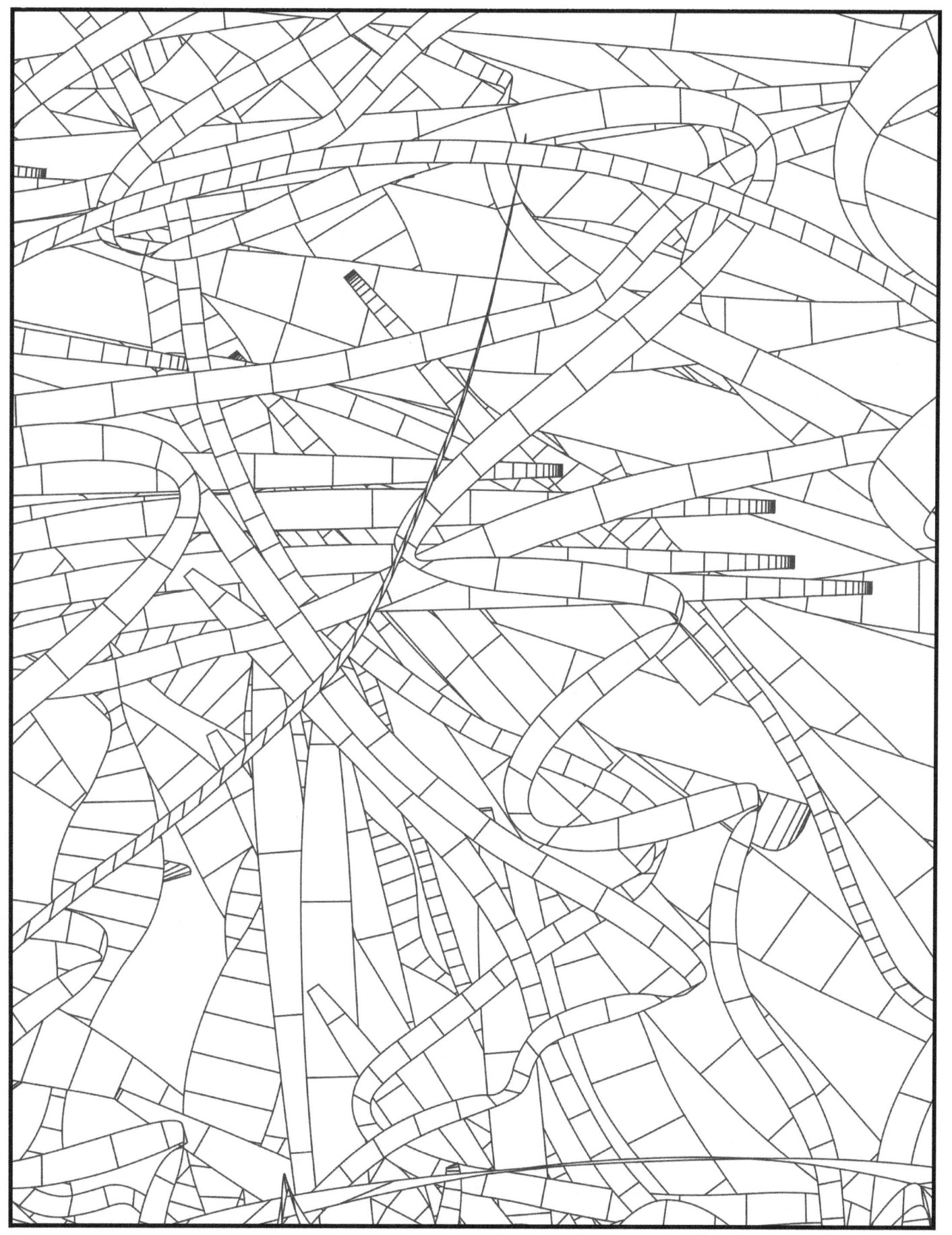

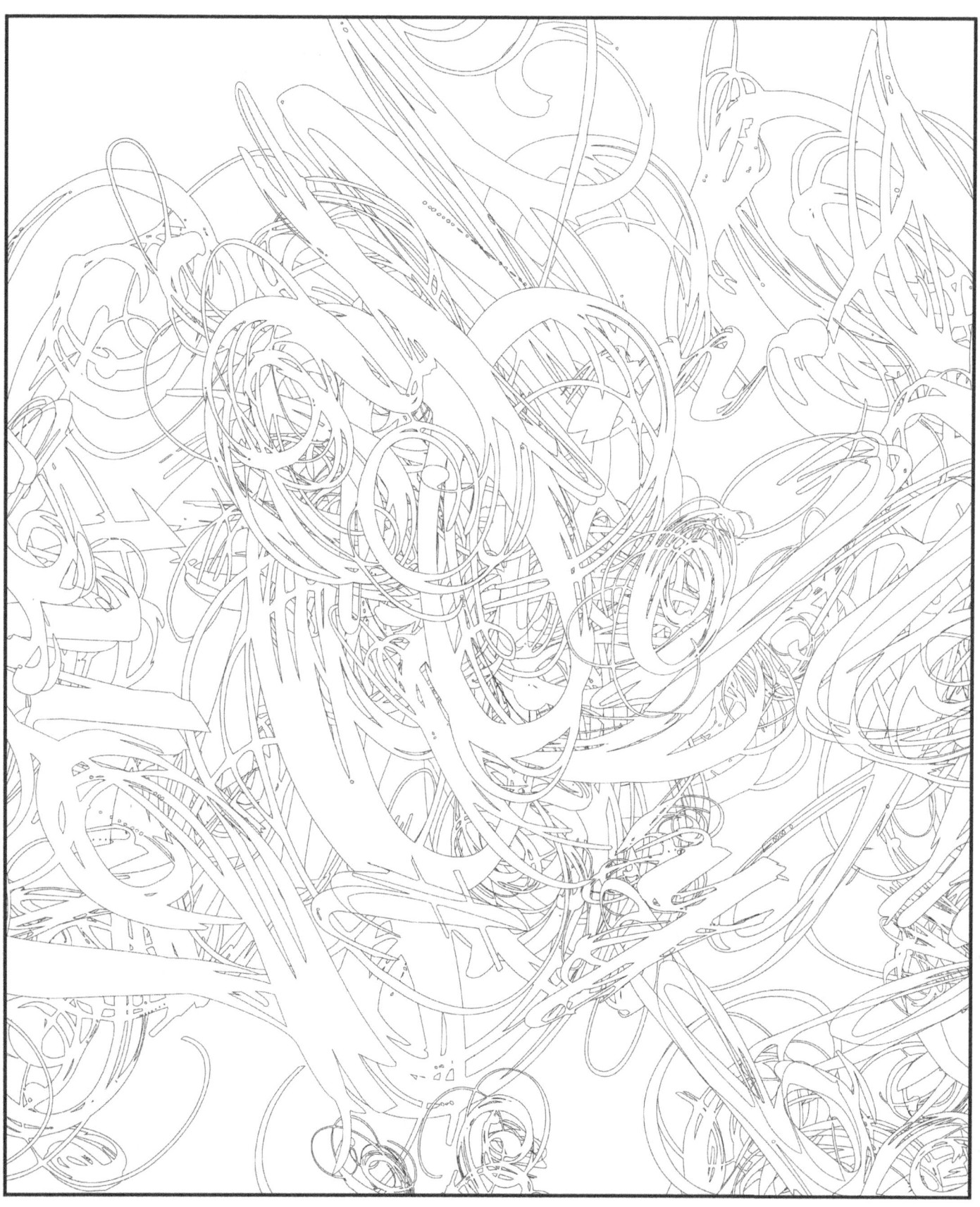

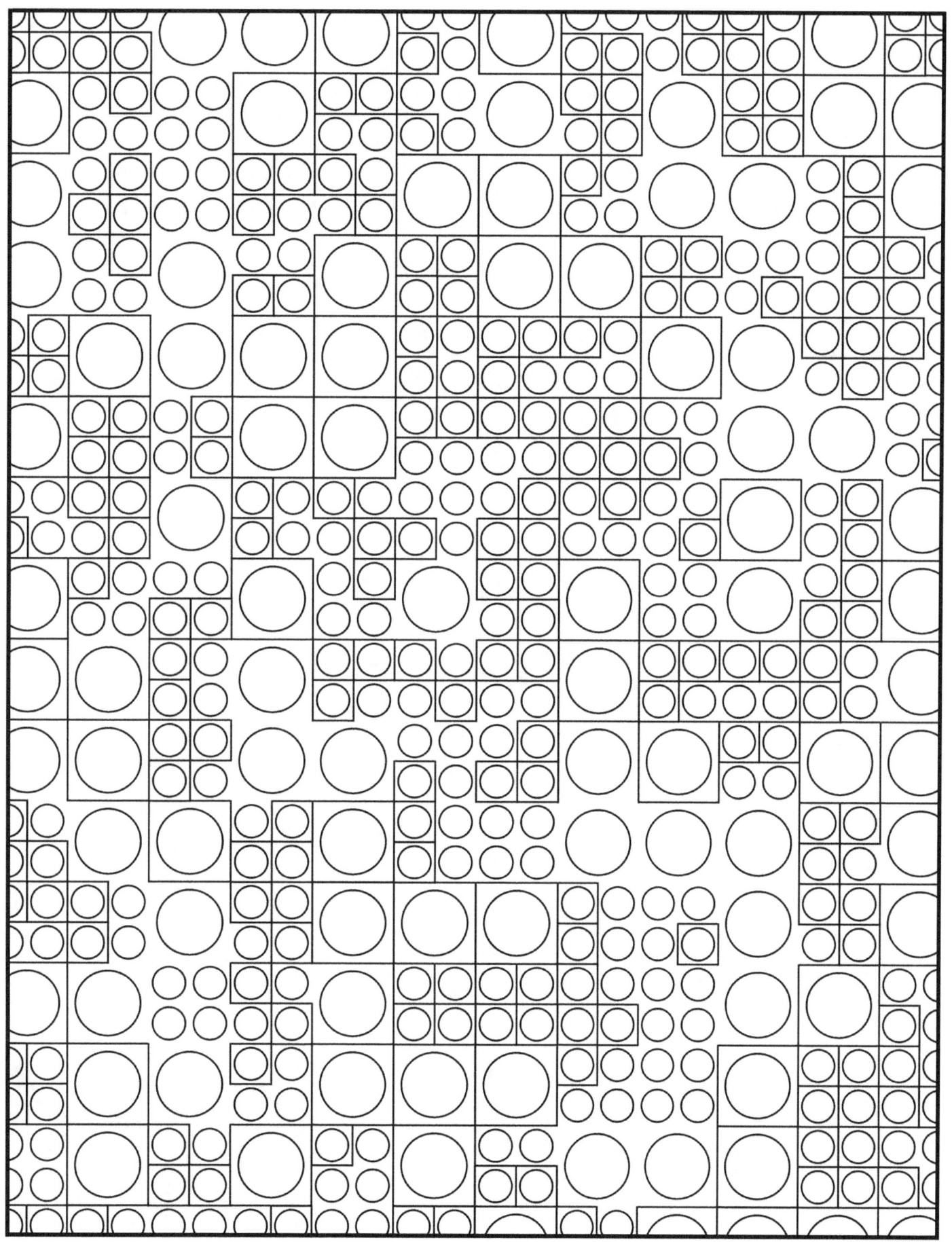

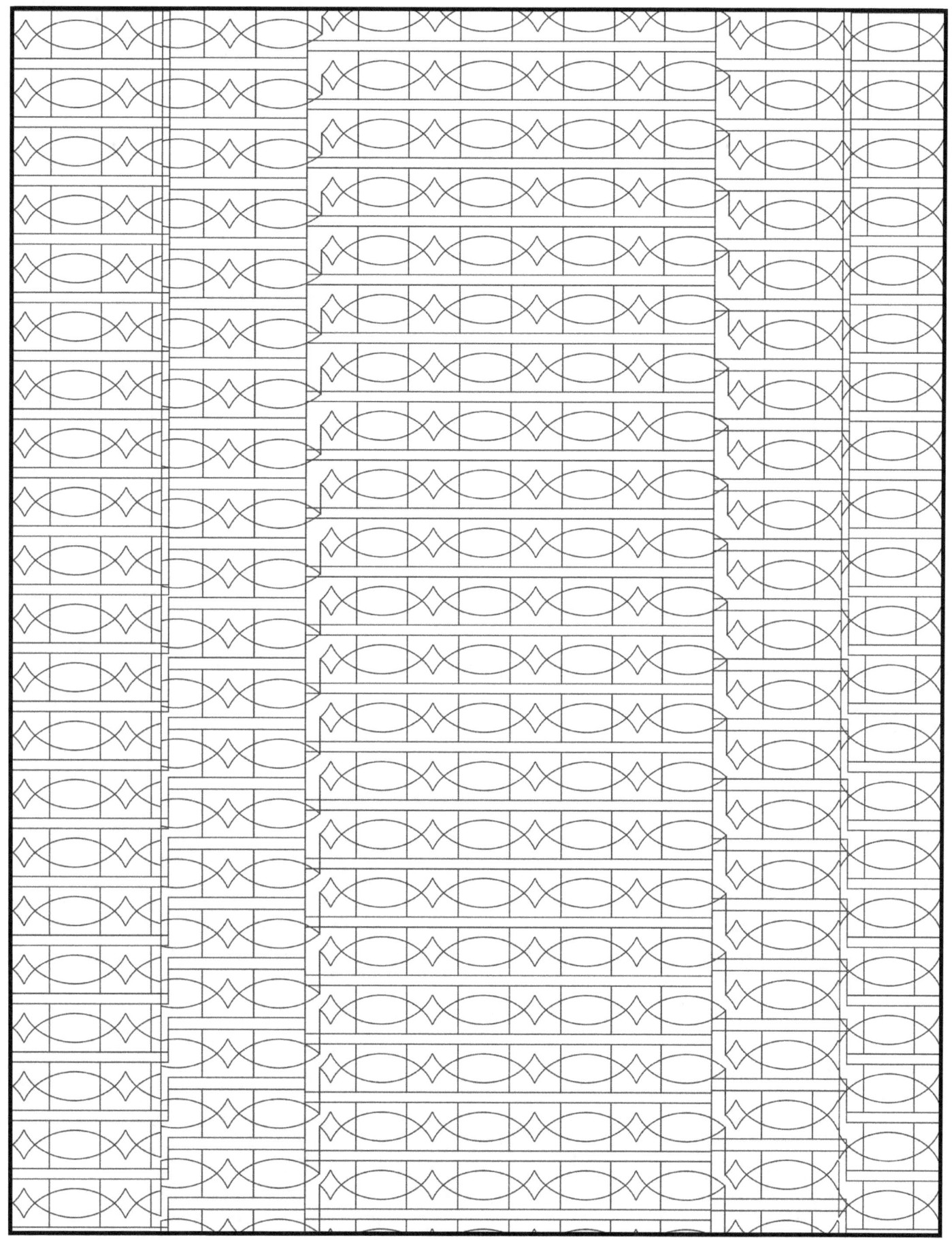

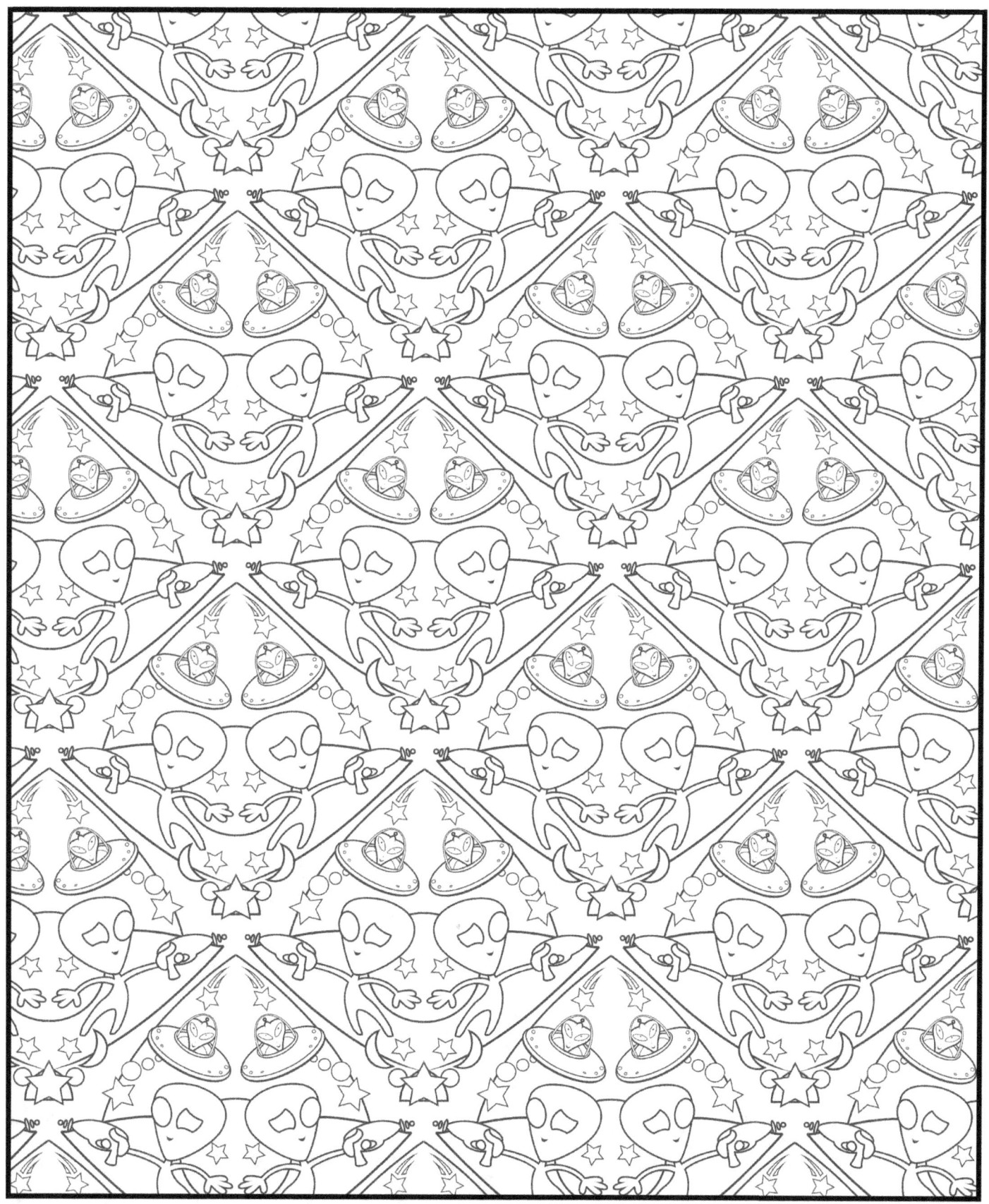

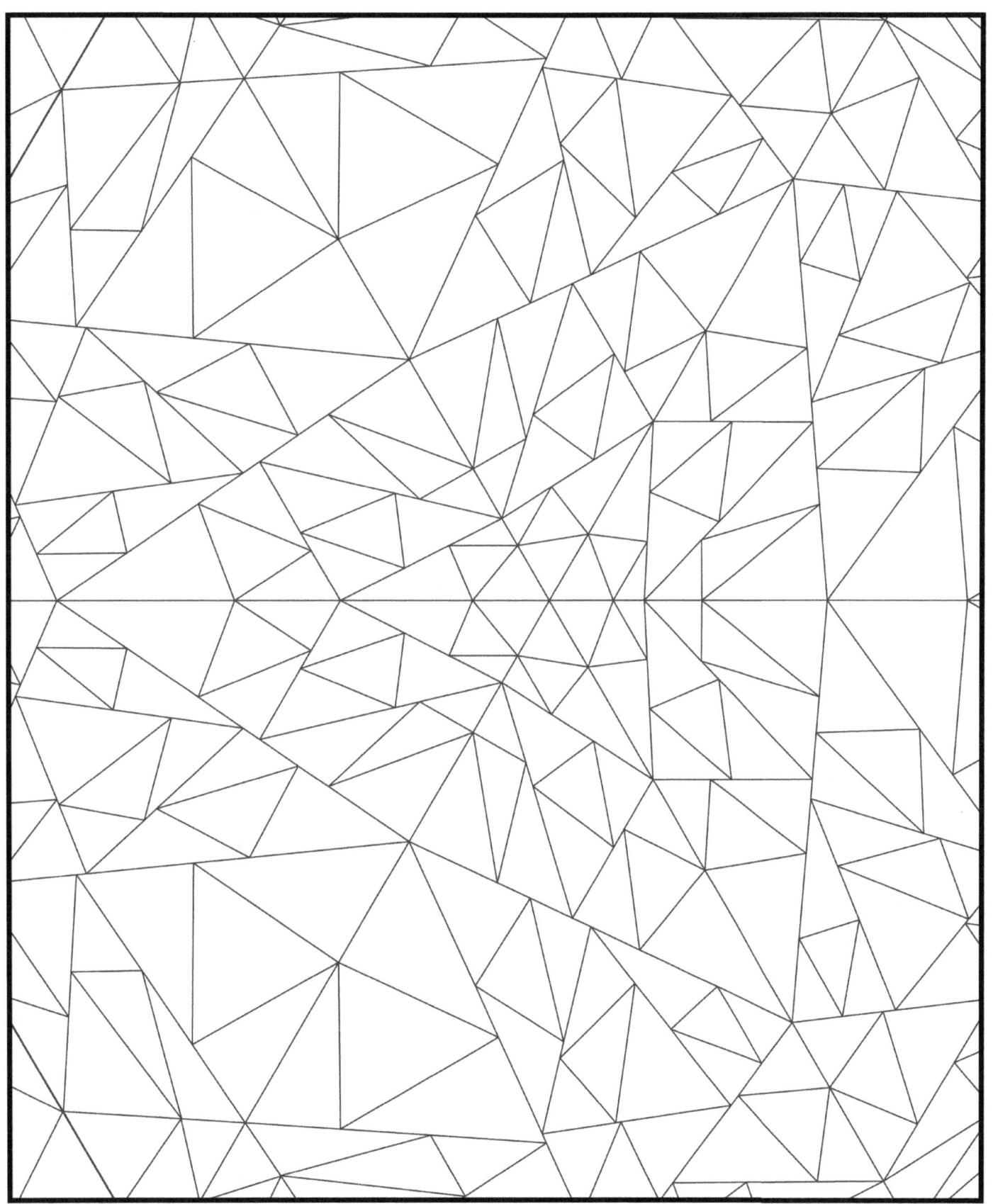

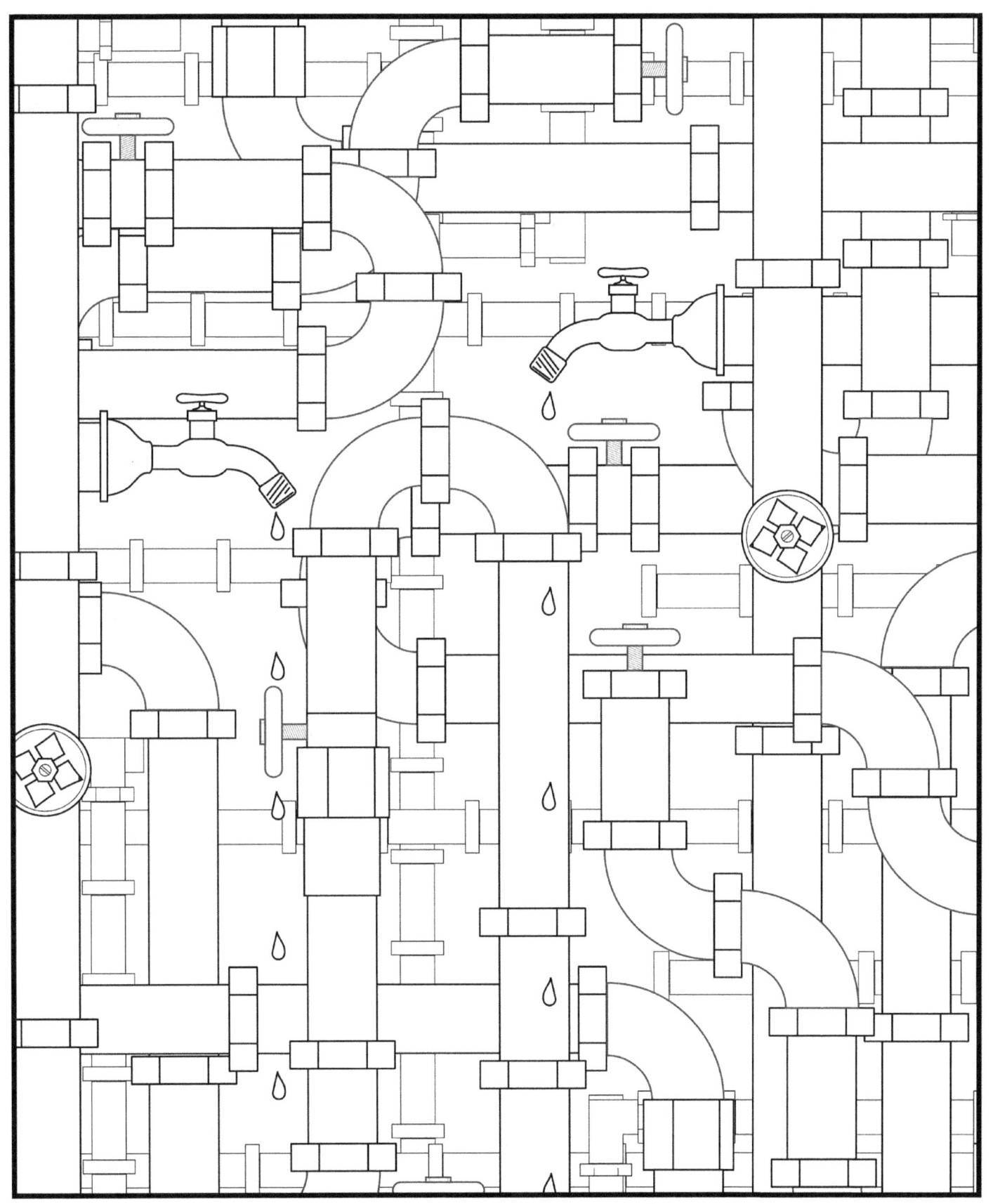

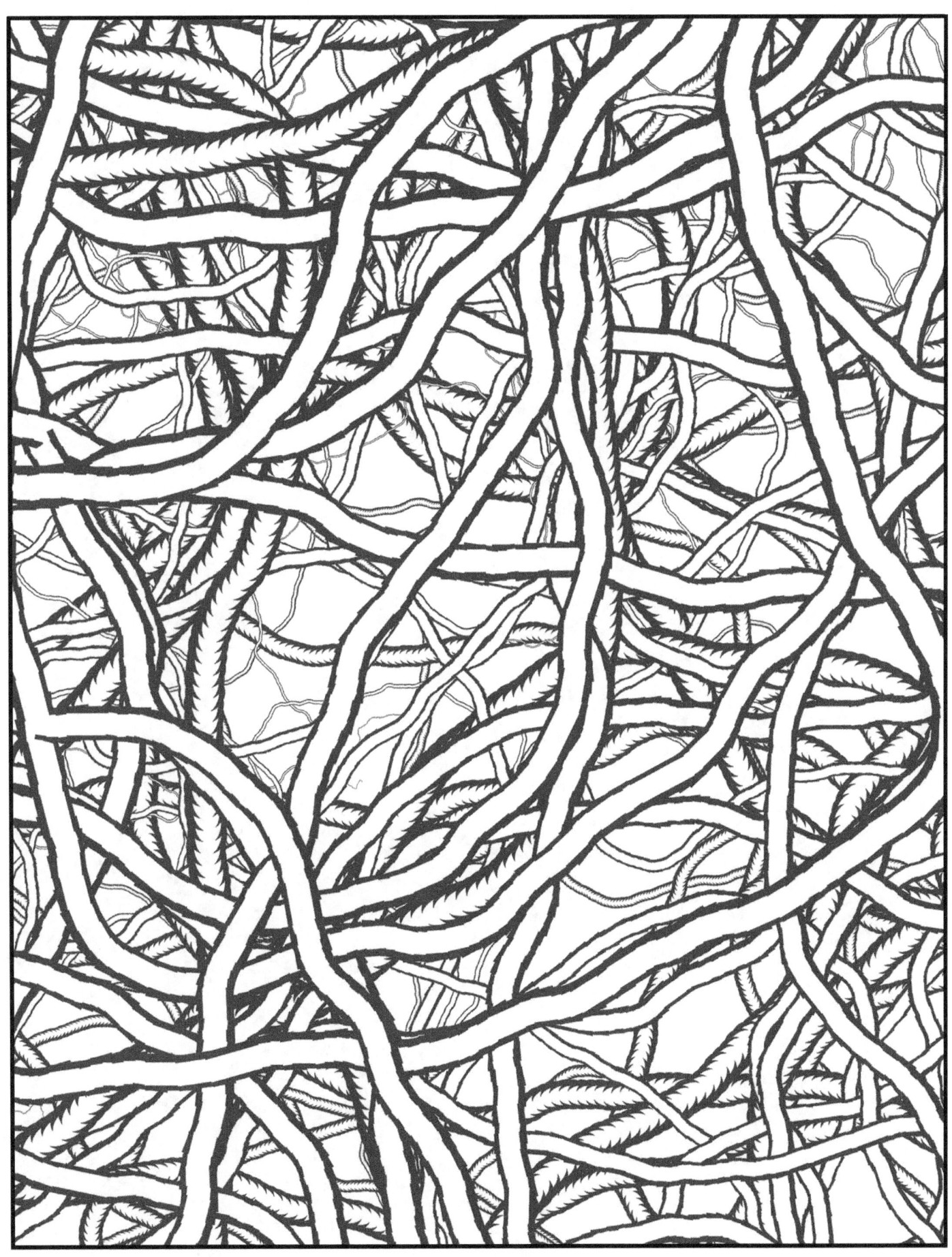

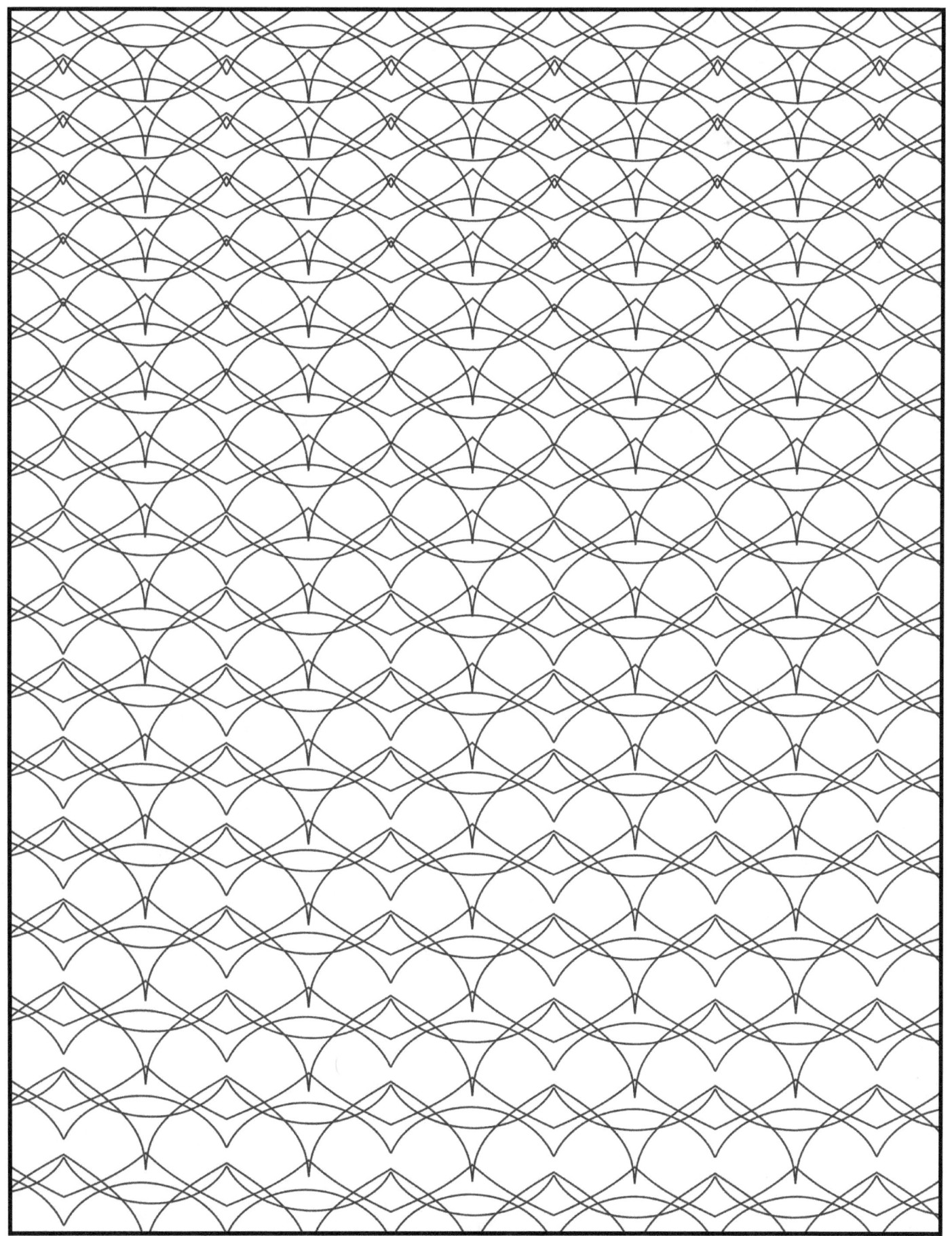

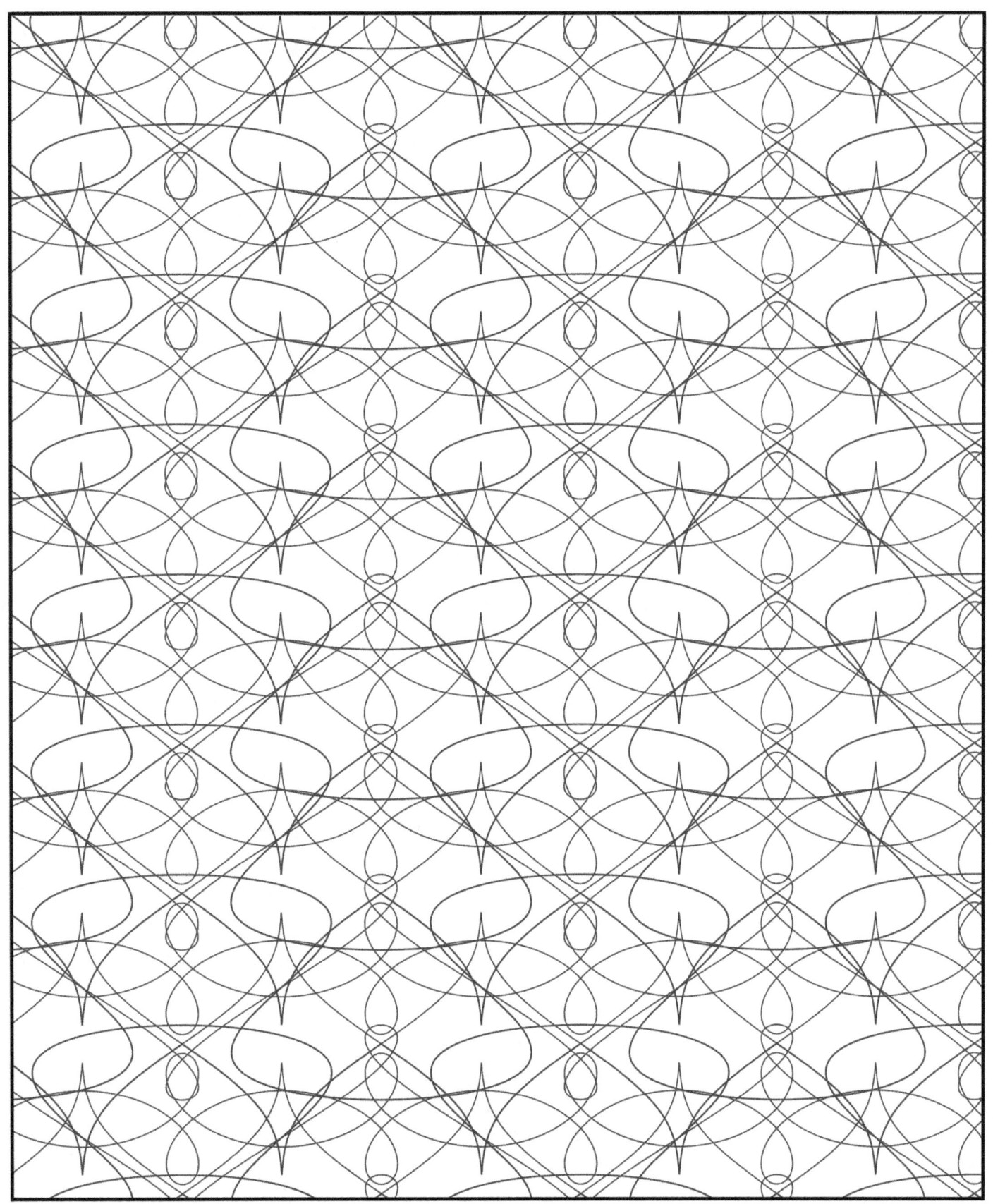

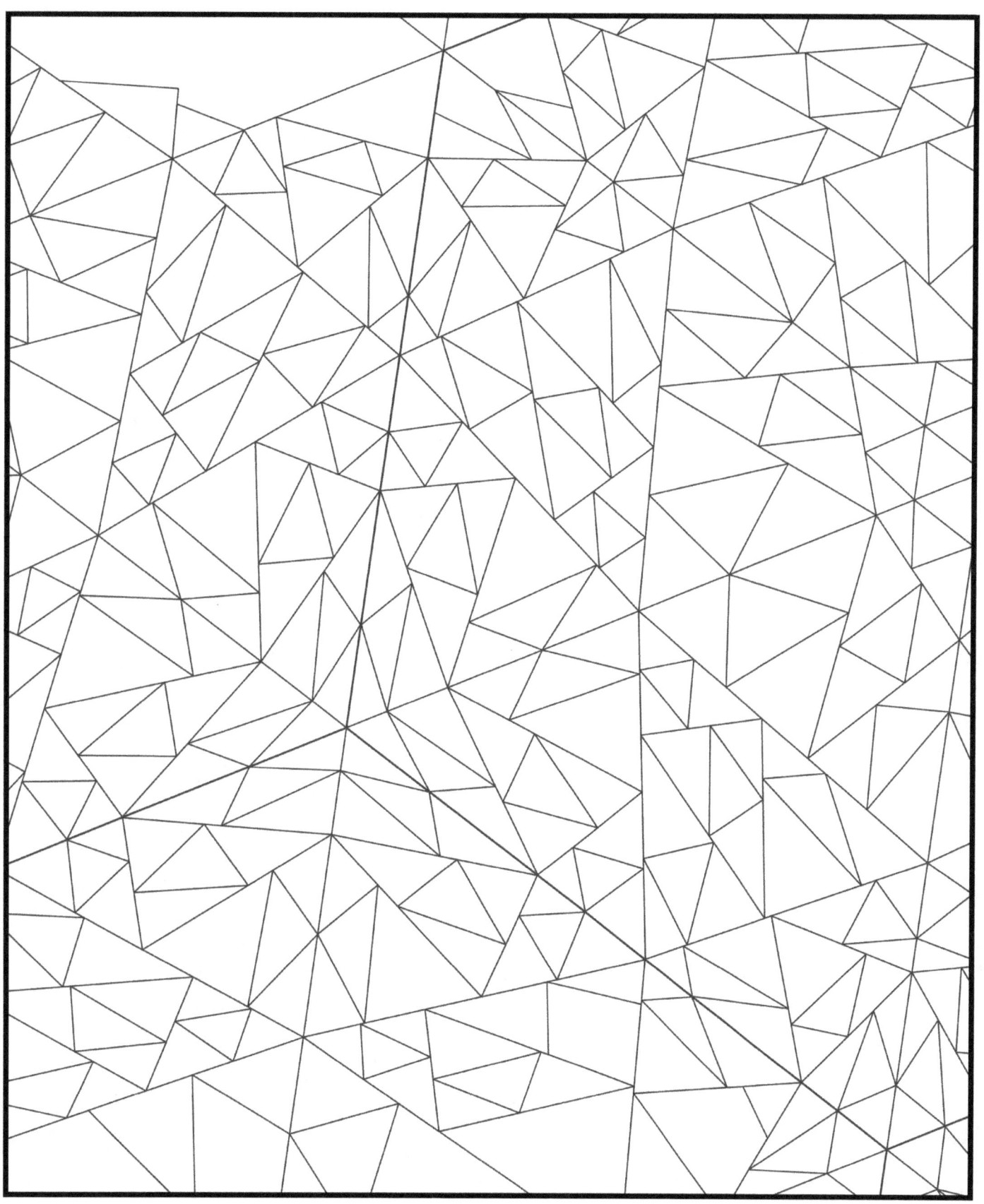

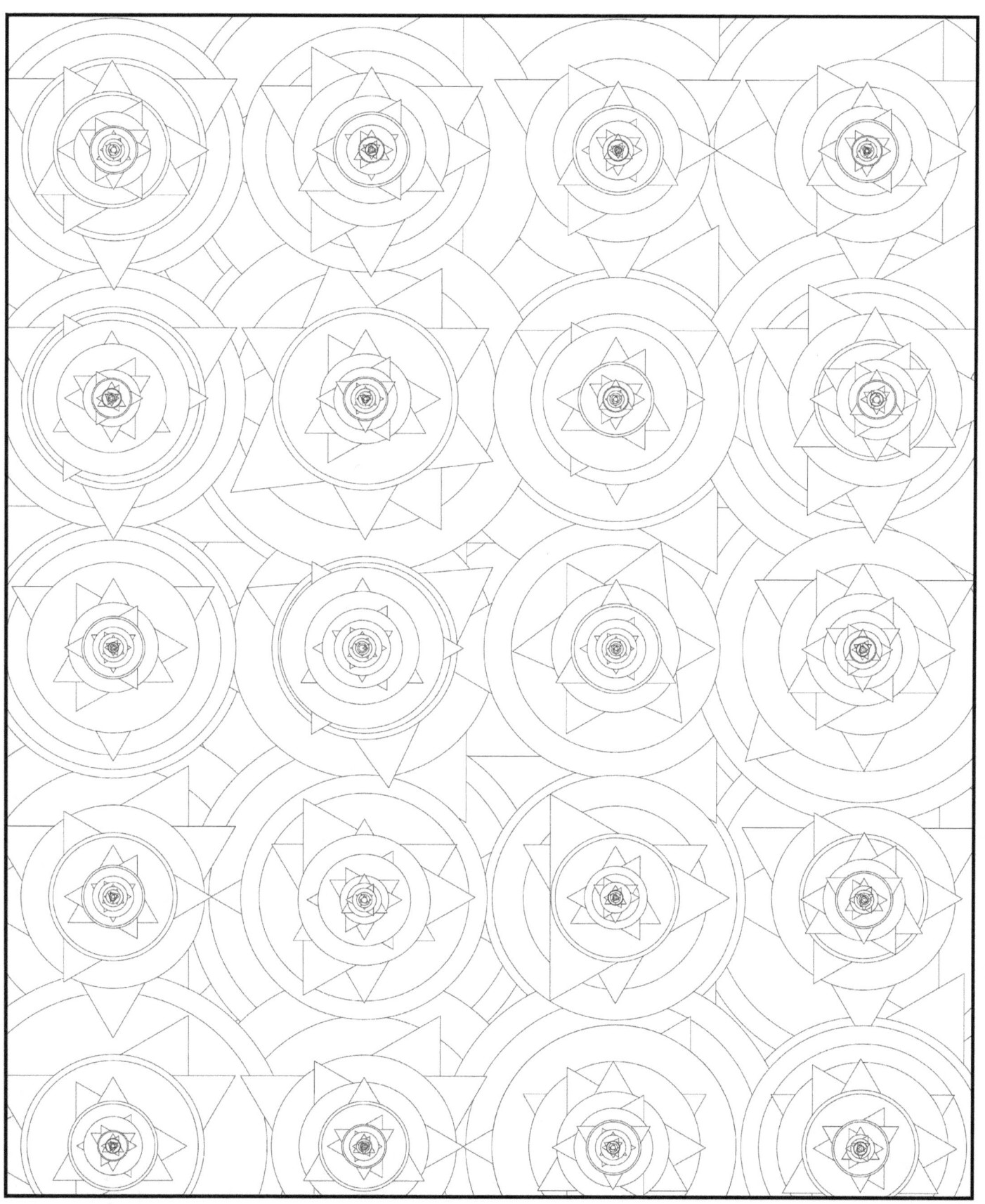

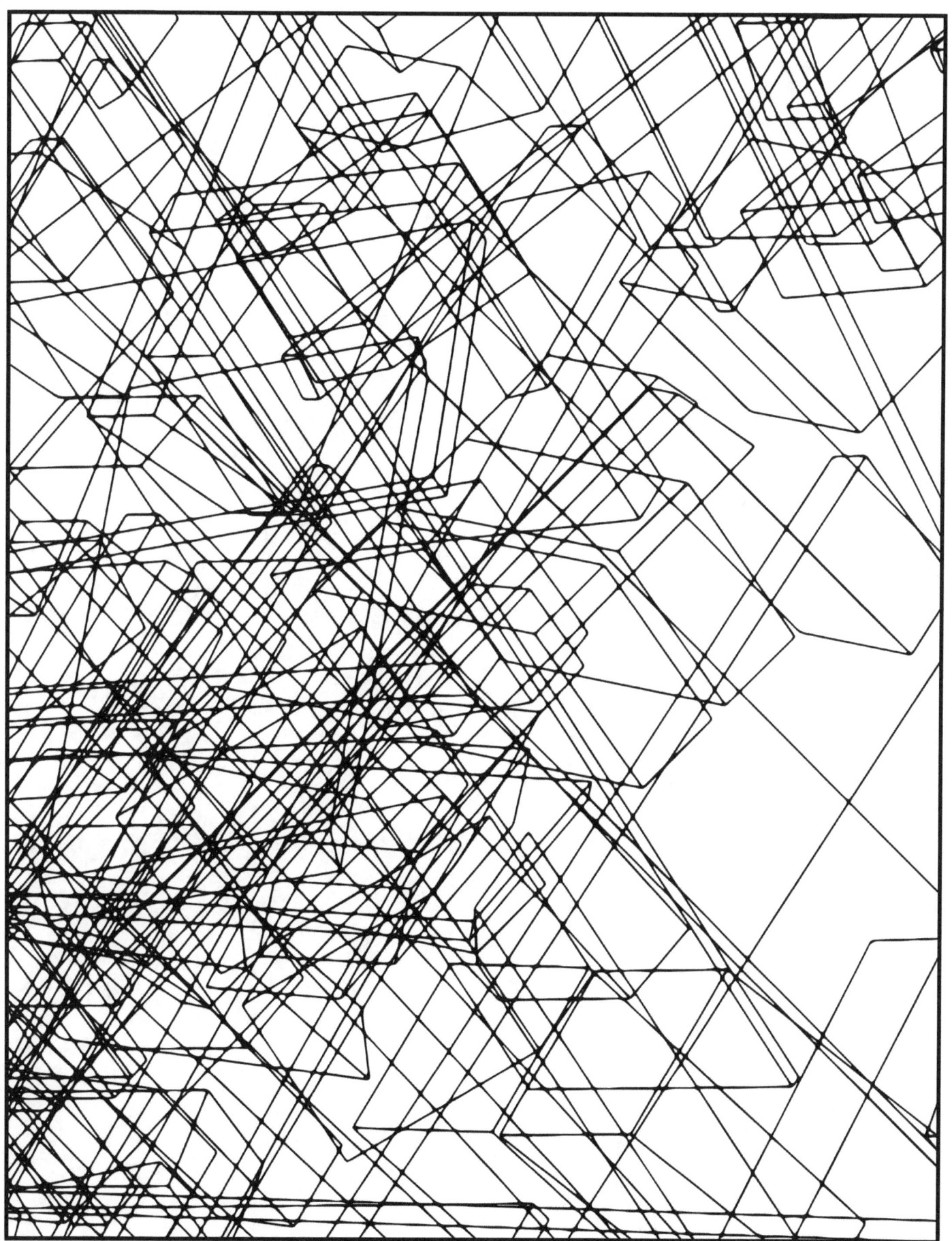

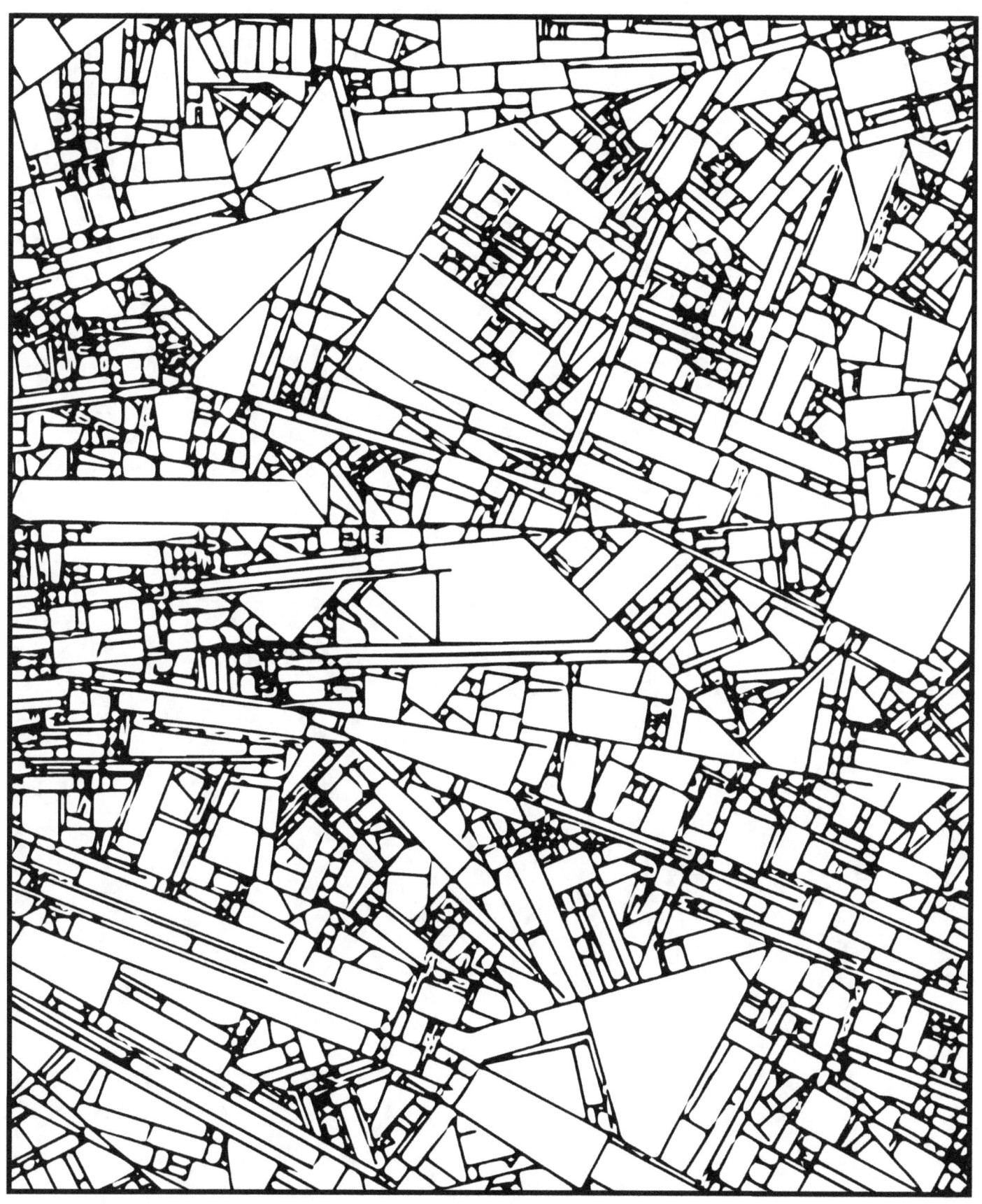

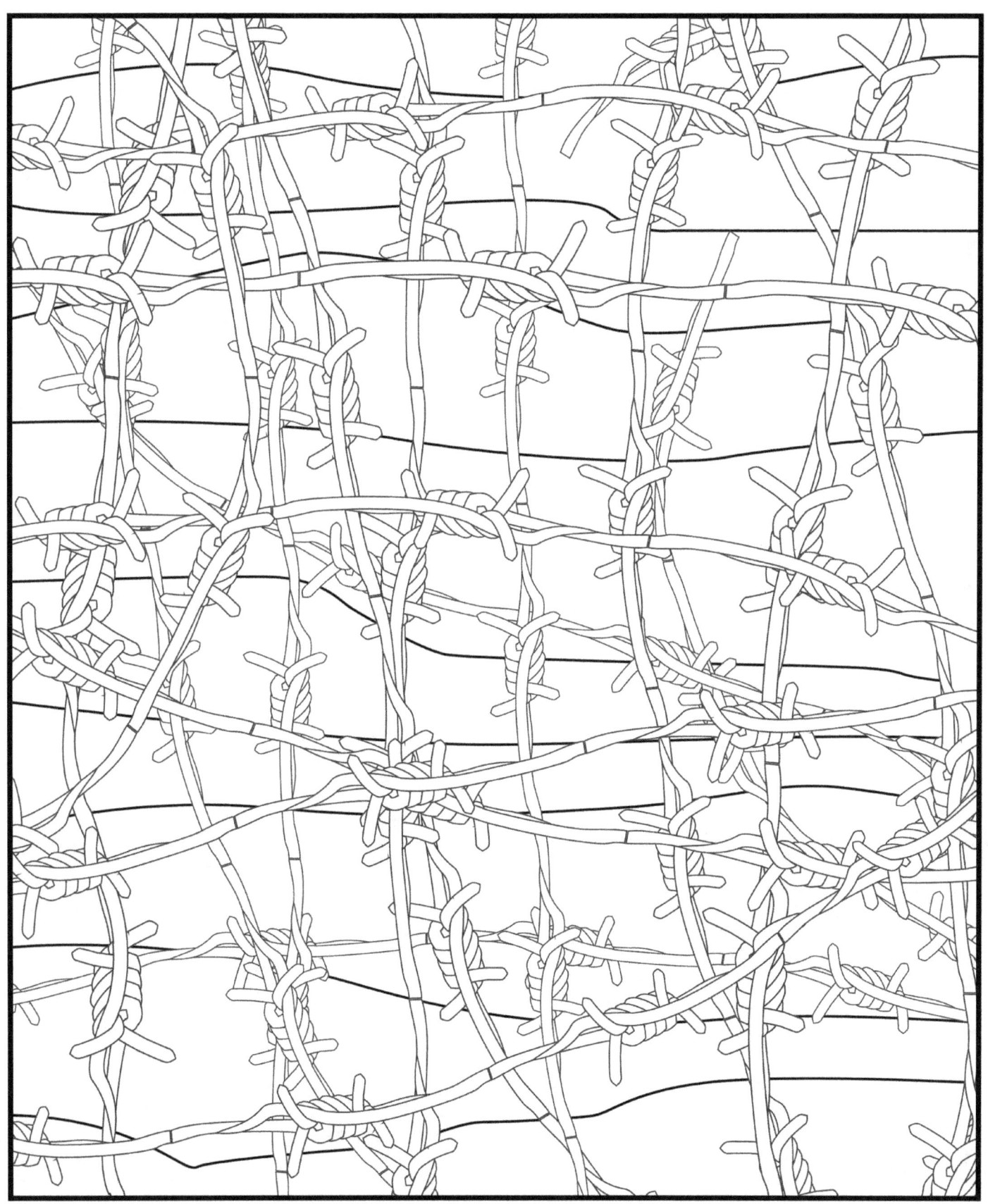

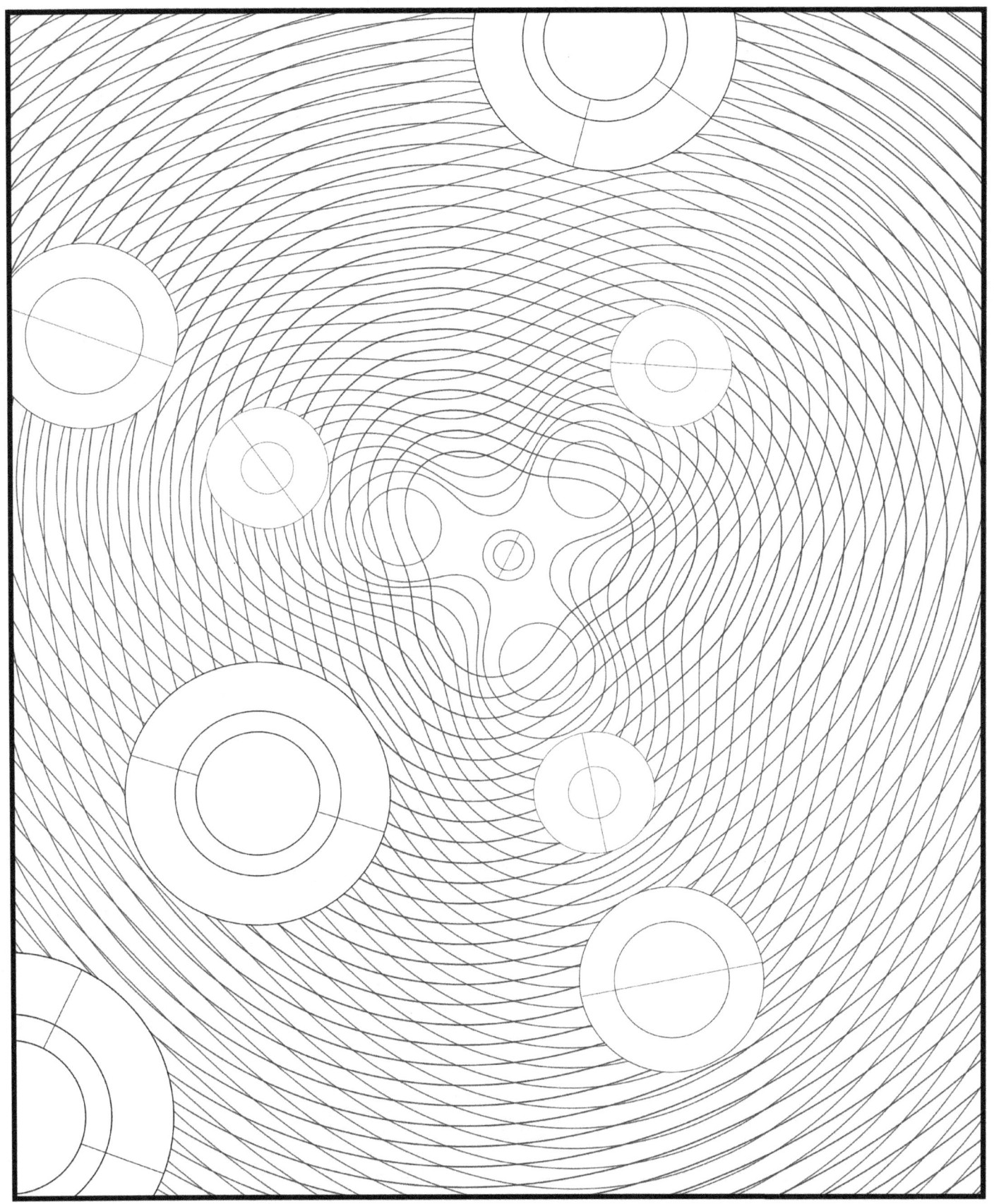